Bronze Head from the

Editha Platte, with Musa Hambolu

THE BRITISH MUSEUM PRESS

Editha Platte has asserted the right to be identified as the author of this work

First published in 2010 by
The British Museum Press
A division of The British Museum Company Ltd
38 Russell Square,
London WC1B 3QQ

www.britishmuseum.org

A catalogue record for this book is available from the British Library

ISBN 978-0-7141-2592-3

Designed by Esterson Associates
Typeset in Miller and Akzidenz-Grotesque
Printed and bound in China
by C&C Offset Printing Co., Ltd

Map on p. 4 by David Hoxley. The names shown and the designations used on this map do not imply official endorsement or acceptance by the British Museum.

Acknowledgements

Biodun Adediran, Sikiru Adedoyin, Marcus Olabode Adeshina, Claude Ardouin, Peter Breunig, Mamadou Diawara, Joseph Eboreime, Stefan Eisenhofer, Violetta Ekpo, Musa Hambolu, Julie Hudson, Adam Jones, Peter Junge, David Killick, Jonathan King, Karl-Heinz Kohl, Richard Kuba, Michelle Marx, Felicity Maunder, Stefanie Michel, Ronja Metzger, David Noden, Michaela Oberhofer, Nathaniel Ogunmola, Kerstin Pinther, Barbara Plankensteiner, Suzanne Preston Blier, Wumi Raji, Katja Rieck, Bosoma Sheriff, Peter Steigerwald, Christine Stelzig, Gabriele Weisser.

Contents

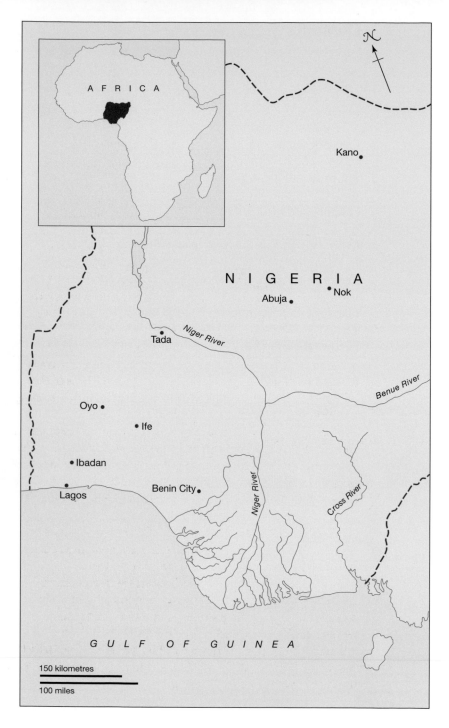

AFRICA

N

Kano

NIGERIA

Nok

Abuja

Niger River

Tada

Benue River

Oyo

Ife

Ibadan

Niger River

Cross River

Benin City

Lagos

GULF OF GUINEA

150 kilometres

100 miles

Chapter 1
Introduction

In 1938 thirteen bronze heads were unearthed in the Nigerian city of Ife; shortly after, another four were found at the same place. Two of the nearly life-size representations of human heads wore a crown with crest and rosette. One of these extraordinarily elaborate crowned sculptures arrived at the British Museum soon after its discovery in 1939, and is currently the only known Ife bronze outside Nigeria (Figs 1 and 2). The second crowned head (Fig. 4) was returned to Ife in 1950 after twelve years in the USA. The whereabouts of a third, which had been unearthed previously in the grove of the Yoruba deity Olokun, have been unknown since shortly after it was dug up in 1910. Since their discovery the bronze heads have been thought to be realistic or idealized portraits of sacred rulers of the kingdom of Ife, which was by the twelfth century a flourishing artistic and political centre. The sculptures are believed by some to have played a central role in a royal ancestor cult in which materialized representations of the otherwise invisible ruler were presented to the public during annual rituals held in certain shrines and groves.

The head in the British Museum was cleaned and examined there in 1947–8, along with other bronze heads found at Ife. From this analysis we know that it is made from leaded zinc brass. The word 'bronze' should therefore be understood hereafter as a convention referring to objects that correctly should be described as 'brass' or 'zinc brass'.

Since the bronze heads from Ife looked very different from many African objects known in Europe at that time, they immediately attracted the attention of the Western press. The *Illustrated London News* celebrated them in 1939 as the 'Legacy of an unknown Nigerian "Donatello"', describing them as 'mysterious' and interpreting them as 'portrait heads' (Fig. 3). The bronzes were equally 'shocking' to the critic Maurice Collis, writing in the British magazine *Time and Tide* in 1948, when they were first put on display at the British Museum:

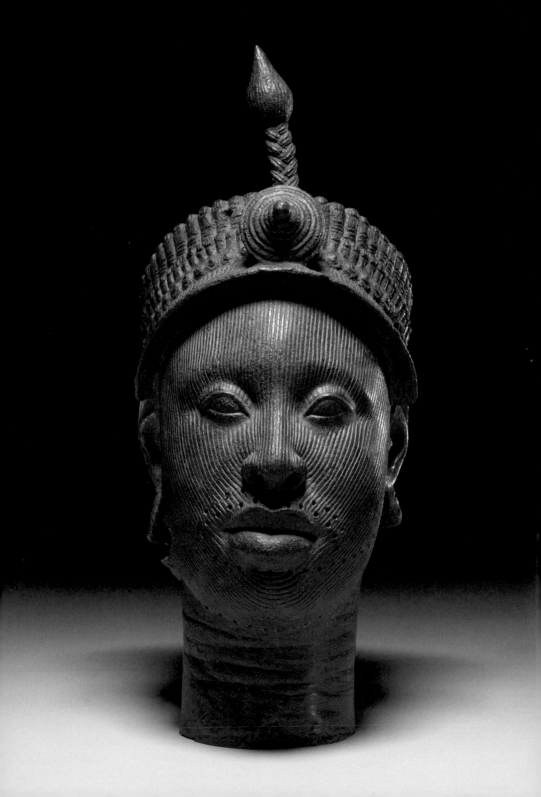

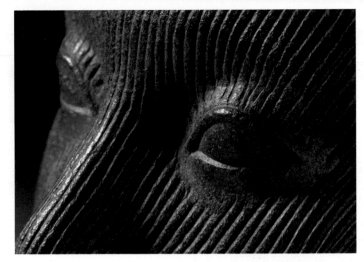

1 *left* Crowned head found in 1938–9 at the Wunmonije compound, Ife, Nigeria. Brass, H. 36 cm. British Museum

2 *right* Detail of the face.

The British Museum Bronzes, however, have no resemblance to the abstract transcendental masks of spirits, which took us by storm, but are like Renaissance sculptures . . . Experts believe them to be about five hundred years old. In that case the artists who made them were Donatello's contemporaries. It is chastening to reflect that in the Africa of that date there lived Negro artists whose work was comparable to that master's. What a mystery! How did it happen?

The fascination sparked by the Ife heads was due to both their proposed age – they are believed to date from the twelfth to the fifteenth century – and their conventional appearance by European standards. They represent an artistic tradition of naturalistic bronze casts, whereas most African art known to the European public at that time was abstract sculpture carved from wood. Made with a great deal of skill, the heads strongly reminded the European public of their own art history, and thus it was not believed that they had been created by African artists. Instead it was assumed either that they had been produced by an artist outside Africa and then imported into Ife or that they had been made inside Africa by an artist trained in Europe. It was equally speculated that the objects must be remnants

MYSTERIOUS IFE BRONZE HEADS:
AFRICAN ART WORTHY TO RANK WITH THE FINEST WORKS OF ITALY AND GREECE.

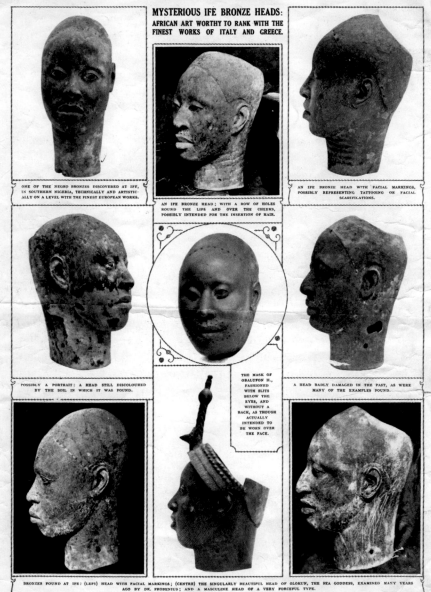

ONE OF THE NEGRO BRONZES DISCOVERED AT IFE, IN SOUTHERN NIGERIA, TECHNICALLY AND ARTISTICALLY ON A LEVEL WITH THE FINEST EUROPEAN WORKS.

AN IFE BRONZE HEAD; WITH A ROW OF HOLES ROUND THE LIPS AND OVER THE CHEEKS, POSSIBLY INTENDED FOR THE INSERTION OF HAIR.

AN IFE BRONZE HEAD WITH FACIAL MARKINGS, POSSIBLY REPRESENTING TATTOOING OR FACIAL SCARIFILATIONS.

POSSIBLY A PORTRAIT: A HEAD STILL DISCOLOURED BY THE SOIL IN WHICH IT WAS FOUND.

THE MASK OF OBALUFON II., FASHIONED WITH SLITS BELOW THE EYES, AND WITHOUT A BACK, AS THOUGH ACTUALLY INTENDED TO BE WORN OVER THE FACE.

A HEAD BADLY DAMAGED IN THE PAST, AS WERE MANY OF THE EXAMPLES FOUND.

BRONZES FOUND AT IFE: (LEFT) HEAD WITH FACIAL MARKINGS; (CENTRE) THE SINGULARLY BEAUTIFUL HEAD OF OLOKUN, THE SEA GODDESS, EXAMINED MANY YEARS AGO BY DR. FROBENIUS; AND A MASCULINE HEAD OF A VERY FORCEFUL TYPE.

The bronze heads discovered at Ife, in Southern Nigeria, reveal the Negro bronze-worker as an artist of the first magnitude. Hitherto negro art has generally been synonymous with work of a subjective character, highly stylised, and generally marked by more or less subtle distortions, plainly the product of a mentality totally different from that of our own. But the appeal of the Ife heads is immediate and universal. One does not have to be a connoisseur or an expert to appreciate the beauty of their modelling, their virility, their reposeful realism, their dignity and their simplicity. Mr. Bascom, the author of the article dealing with these heads, on page 592, suggests that the heads may be portraits. No Greek or Egyptian sculptor of the best periods, not Cellini, not Houdon, ever produced anything that makes a more immediate appeal to the senses, or is more completely satisfying to European ideas of proportion.

of a Greek colony which had existed several centuries BC and that the Guinea Coast was in fact the lost continent of Atlantis!

It was only after a series of technical and stylistic studies that experts finally came to believe that the bronze heads form part of an African artistic tradition, and represent one of the most outstanding productions of world heritage. As such they influenced not only their immediate environment but also the attitudes of the European public, policy makers, academicians and artists. As one of the most famous objects from the former British colony of Nigeria, the bronze head from Ife has been classified as a masterpiece of the British Museum ever since it arrived there. Equally, it has become an icon of artistic skill and historical meaning in its homeland of Nigeria, and in Africa generally.

The head is important not only as a work of art, but also as a cultural object. It carries huge historical and mythological significance for the Yoruba people, one of the largest ethnic groups in Nigeria, and its history highlights encounters between various other nations and individuals. As well as relating the fascinating story of the head, from its discovery to its exhibition and reception in Britain, this book seeks to explore how it has taken on a new life in modern-day Nigeria, where images of it have abounded since independence was declared in 1960.

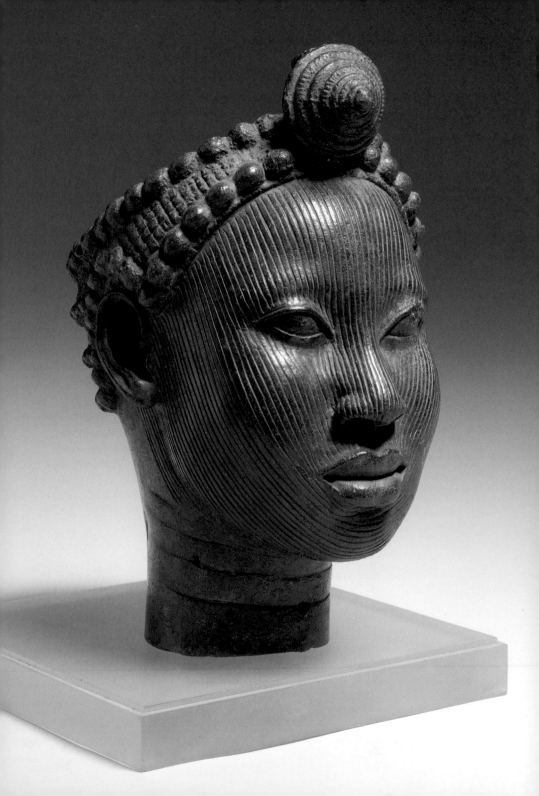

Chapter 2
The crowned heads from Ife

4 *left* Crowned head found in 1938–9 at the Wunmonije compound, Ife. Brass, H. 24 cm. National Museum, Ife. After its discovery this head was taken to the USA by William Bascom. It was returned to Ife in 1950.

Ife was one of the most important Yoruba kingdoms of southern Nigeria, and thought by the indigenous population to be the place where the world was created. The bronze objects, in common with other antiquities found there, were mostly unearthed at groves and shrines in and outside the town. The first of the three known crowned heads was acquired in 1910 by the German traveller and ethnographer Leo Frobenius at the grove of Olokun, a deity of the Yoruba people. Other sculptures were also found at palaces of the Oni, the sacred king and ruler of Ife (Fig. 5).

Two sites in particular are key to the discovery of antiquities in Ife. The first is the Wunmonije compound (Fig. 6), which is situated right in the centre of the town and belonged to an Oni in the mid-nineteenth century. It was here that the head now at the British Museum was unearthed in the late 1930s, along with a number of uncrowned bronze heads. Like many Ife antiquities, they were discovered accidentally during building works by local inhabitants of Ife, untrained in the careful handling of objects regarded as precious artefacts by museums and art

5 Ife priests with terracotta heads. Wilfrid Dyson Hambly, *Cultural Areas of Nigeria*, Chicago 1935, pl. 157.

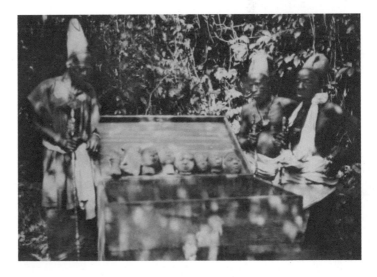

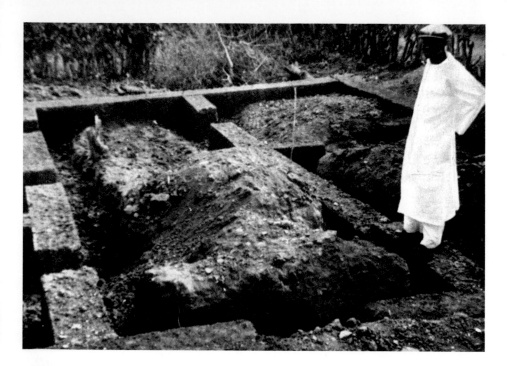

6 Excavations at the Wunmonije compound at Ife.

dealers. For this reason a number of the excavated items were unintentionally damaged by pickaxes made to dig into heavy soil rather than vulnerable archaeological material: quite a number of objects ended up with holes in their jaws or heads or, in the case of terracotta works, lost the crests that once formed part of their headdresses (Fig. 7).

One might assume that the objects would have suffered much more damage had one Oni of Ife, Adesoji Aderemi (r. 1930–80), not been deeply committed to the preservation of Yoruba culture. He encouraged people to bring him any antiquities that they found and stored them in his palace for safekeeping. These artworks formed the nucleus of the National Museum at Ife, which opened in 1954 in an area of the palace specially given over for the purpose by the Oni.

The second key archaeological site in Ife is Ita Yemoo, where objects linked to the group of crowned bronzes were unearthed in November 1957 during the levelling of the ground for a road. These discoveries were made much more systematically than the earlier finds, owing to the

establishment in 1943 of a government Antiquities Service in Nigeria. Bernard Fagg, at that time the government archaeologist in Nigeria, who had worked for the colonial administration since 1939, led the investigation of the site, together with the later doyen of Ife archaeology, Frank Willett.

Though other excavations uncovered equally impressive objects, including a large corpus of outstanding terracotta heads, it was at these two sites that the majority of the copper alloy (bronze) sculptures for which Ife became famous were discovered. Most of the antiquities remain in Ife, which is where they were most probably made. However, a few pieces left Nigeria, and are now in the collections of major museums. The head bought for the British Museum was acquired in Nigeria in 1939 by a journalist from the *Daily Times*, and further sold and resold until it was finally handed over to the National Art Collections Fund, Britain's principal charitable art organization. Two other heads – a crowned head with a broken crest (Fig. 4) and a life-size bronze head without a crown – were bought by the American anthropologist William Bascom, who was carrying out research for his Ph.D in Ife at

7 Broken-off terracotta crests found at Ita Yemoo, Ife.

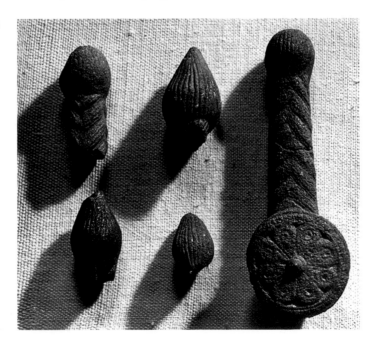

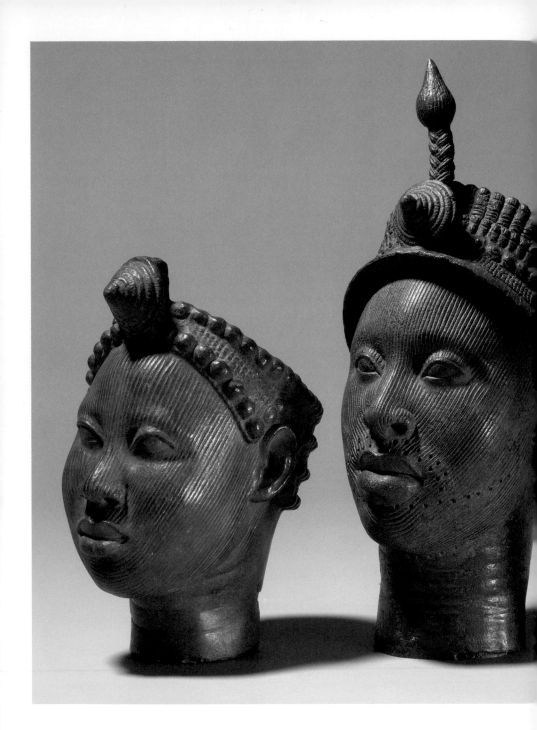

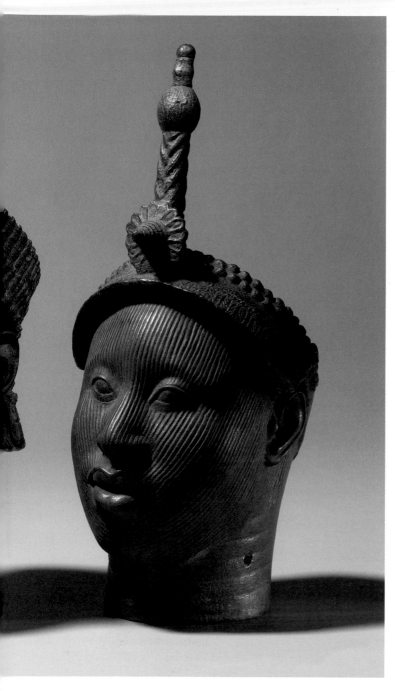

8 The British Museum
crowned head (centre)
alongside casts of the
crowned head now
in the National Museum
at Ife (left) and the
'Frobenius head',
now most probably
lost (right).

the time of the discoveries. He took the heads to America, where they were widely exhibited but then returned to the Oni in 1950 to be placed in the new museum at Ife.

The three known crowned bronze heads can be called the 'Frobenius head', found by Leo Frobenius in 1910 and now most probably lost; the 'Ife head', unearthed in 1939, acquired by Bascom and later returned to the National Museum of Ife; and the 'British Museum head', also unearthed in 1939. All three heads are commonly referred to as 'Olokun' or 'Ori Olokun', although strictly speaking just the 'Frobenius head' should be called this, as it was the only one found at the grove of the sea-goddess Olokun. The use of the name for all three may be due to their striking similarities at first glance (Fig. 8).

Formal characteristics

None of the three crowned heads is life-size; the one in the British Museum is about three-quarters life-size. It is impressively made in the lost-wax technique, and all parts of the head are rendered in an extraordinarily skilled manner, giving it a charismatic appearance. The face is covered with incised striations, but the lips are unmarked. Holes are pierced in a double row above the upper lip; additional lines of holes are applied along the chin and cheek, leading from one ear to the other (Fig. 9). The jaw is broken on the right side, the missing part leaving a hole. The almond-shaped eyes are placed under outlined eyebrow-ridges and the ears are stylized. The headdress suggests a crown composed of different layers or rows of disc- and tube-shaped beads and fitted tassels or hair. Between the crest and the face is an arc running around the forehead and a section – maybe also suggesting plaited hair – covering the nape of the neck where two lateral holes are placed. The inside of the sculpture is hollow, with both the top and the bottom left open (Fig. 10). What makes the head very special is the crest, which is attached over the forehead and comprises a rosette and a plume in the form of a plaited element now slightly bent to the right (Fig. 15). While the face is covered by a mostly dark green patina, the crown has sections painted in red.

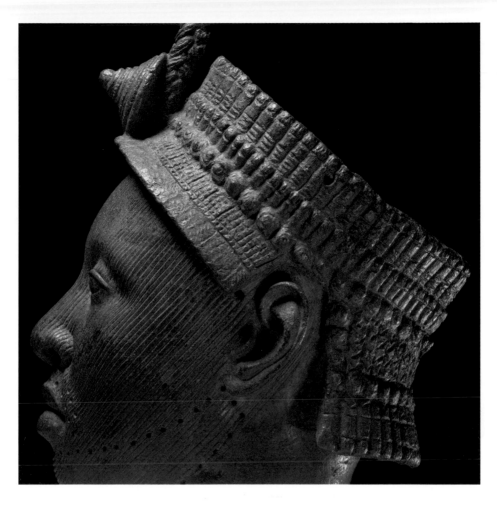

Method and materials

The three principal materials used in ancient Ife are brass,
terracotta and stone; the crowned heads with crests only
seem to have been made out of the first two. The use of iron,
known from several artworks, is also documented for the
bronze heads, some of which have the remains of iron pins
used to secure the clay core during the casting process.

Since we are quite sure that brass (copper-zinc alloy) was
not made in West Africa before the twentieth century, we
can assume that the material for the bronze head came from
a source outside Nigeria. In 1951 Kenneth Murray and

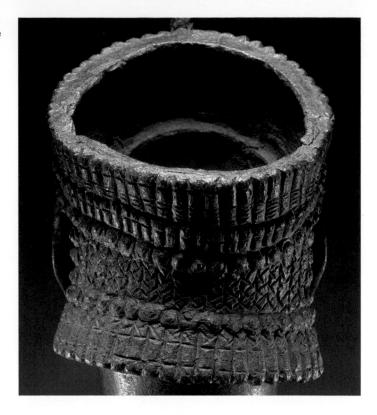

Bernard Fagg, successive Directors of Antiquities in
Nigeria, suggested that the copper used for the heads was
either brought across the Sahara Desert from Europe or
came from Darfur in modern Sudan. But the origin of the
copper is not yet resolved, nor is the study of Ife casting
traditions anywhere near complete. One theory is that the
technical knowledge of lost-wax casting and the raw
materials were obtained via trans-Saharan links and later
passed south to Benin. Another theory speculates that brass
casting was developed locally in Ife.

Each object made in the lost-wax (*cire perdue*) casting
process is unique as the model has to be destroyed once the
object is finished. First, each object is modelled in wax,
usually over a clay core, and covered with further layers of clay.
After baking, the clay hardens and the wax is melted so that
it can be poured off to leave a hollow mould ready to receive

molten metal. Once the metal is poured in and sets, the clay model is broken open and discarded (Figs 11 and 12).

Possible meanings

Early interpretations of the idealized but naturalistic bronze heads from Ife assume that they are portraits of deceased rulers and form part of an ancestor cult. According to this view, the cult was related to some form of divine kingship, like the corresponding cult of early Benin, the associated art of which is thought to have come from Ife. The holes at the neck are taken to indicate that the heads were made to be attached to a wooden body to be placed in a shrine, or presented to the public at certain times of the year. They were periodically buried throughout the year, although not always kept in one place, and grouped together if necessary. They may also have been used in funeral rites to mark the passing of an individual king while celebrating the permanence of kingship.

The bronze heads are part of a wider group of artworks, which includes some extraordinary full bronze figures (Fig. 13) and heads made of terracotta (Fig. 14). Their special features all point towards a context of

11 *right* Diagram illustrating the lost-wax technique.

12 *overleaf* Carl Arriens, 'Bronze casting in Yorubaland', 1912. Plate from Leo Frobenius, *Und Afrika sprach*, I, Berlin 1912, opp. p. 192.

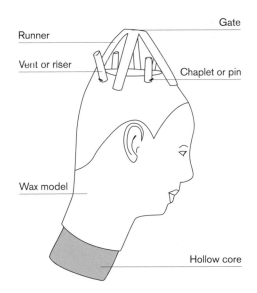

Gate

Runner

Vent or riser

Chaplet or pin

Wax model

Hollow core

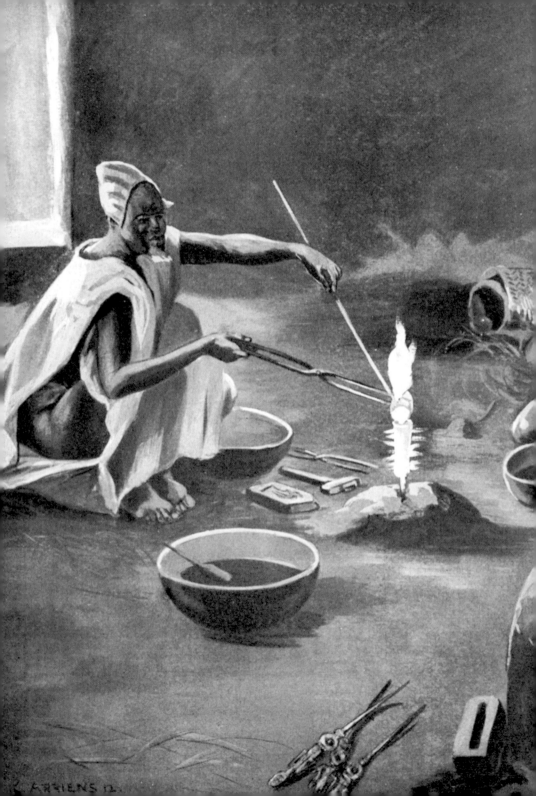

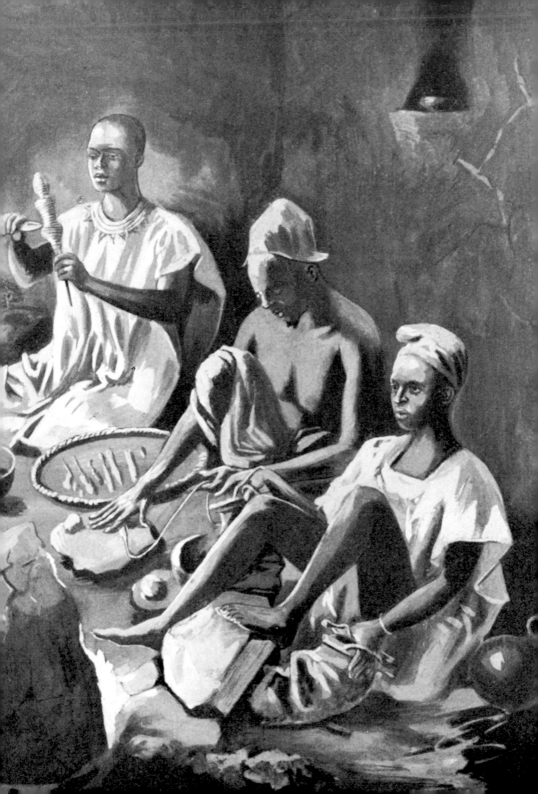

royalty and ancestry, coronation and rulership succession. For example, the figures carry the principal royal insignia – a horn and a bead-embroidered cloth wrapped around a wooden core – and wear the appropriate attire. One theory suggests the facial striations on the heads indicate one ruling Ife dynasty, while those heads without incisions represent another. It has also been suggested that the incisions represent the beaded veil of an Oni or are a visual trick to give the face a natural appearance.

The clearest emblems of rulership are the crown and the crest. They are the essence of kingship and the symbol of the royal ancestral spirit. When the king was not present in person, his crown was publicly displayed instead, usually placed on the throne. The crowns found attached to the Ife antiquities at first sight look different from those of present-day Yoruba Obas (kings), which are conical, very tall and made out of elaborate beadwork (see Fig. 24). Despite this they are in fact quite similar in that the visual prominence of the head is paramount in both.

The headdresses of all the crowned bronze heads consist of two main parts: a circlet suggesting different layers of beads and a crest surmounting the forehead. This construction, sometimes called the 'phallic crest' (Fig. 15), is decorated in different ways. A plaited element, apparently corresponding to the tufts of hair worn in the present-day crowns, appears to be attached to the main structure with a kind of rosette consisting of various discs. The crest of the Ife head is broken off, whereas the one on the Frobenius head is extraordinarily long. The central part of the headdress on the British Museum head is notable because it is much higher than those of the other two known crowned heads. This height is due to the multiple layers of tube-shaped beads apparently applied either to an underlying construction or fixed-on hairs pulled through the beads. The foreheads of the British Museum and Frobenius heads are framed by an arc, which again may symbolize plaited hairs pulled through beads, similar to the section covering the nape of the neck.

Sacred kings have to retain distance from their subjects. This meant that the bronze head – as the representation of royalty or even a specific king – also had to be covered up

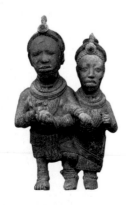

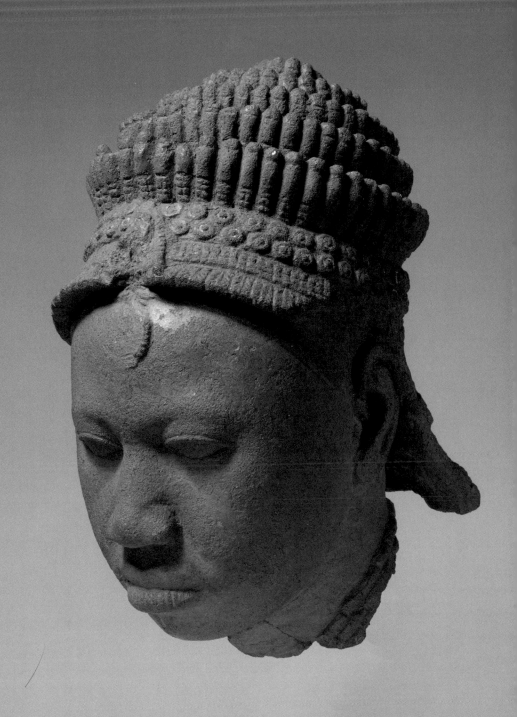

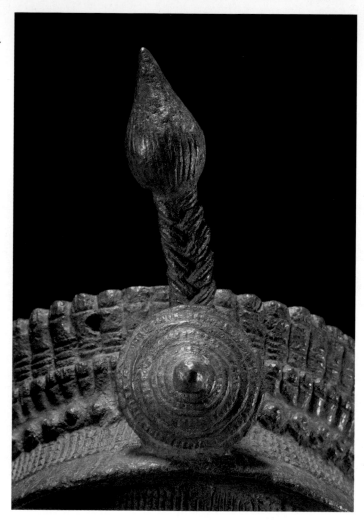

when brought into the public sphere. Therefore the holes around the mouth may have been used to hold strings with beads that would have created a curtain, leaving just the highly stylized eyes exposed. Glass beads were made in Ife and worn together with red stone beads. The striations extended over the face, producing a special impression of the surface that, when displayed in the semi-darkness of a shrine, must have given a dramatic quality (Fig. 16).

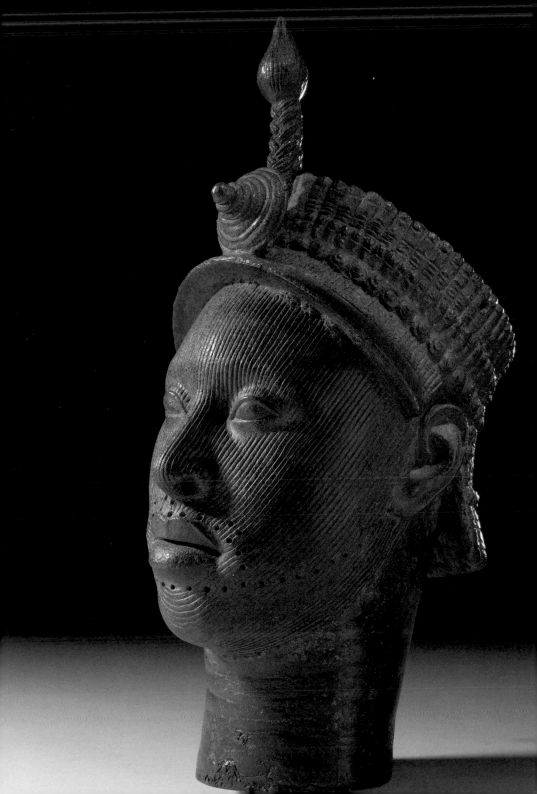

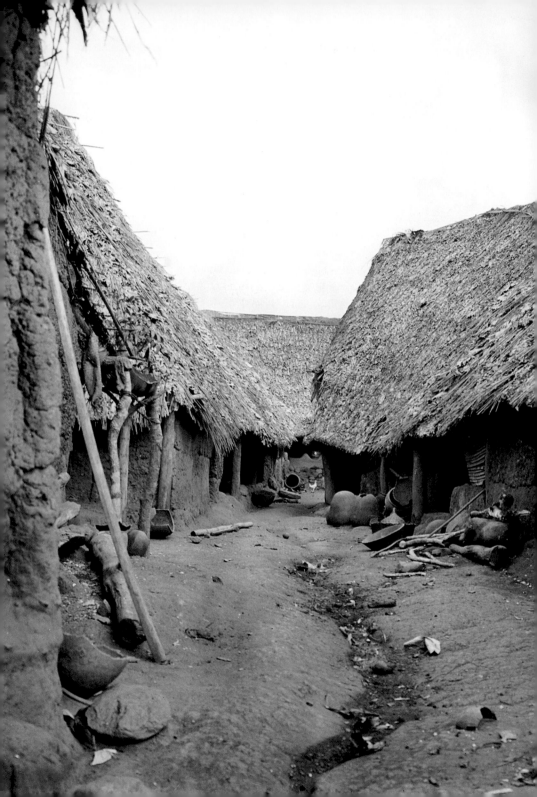

Chapter 3
Folklore and history

In 1897 the historian Samuel Johnson (1846–1901) wrote *The History of the Yorubas From the Earliest Times to the Beginning of the British Protectorate*, one of the most important works on the history of the Yoruba people, which was published posthumously in 1921. Although the book itself focuses on north-east Africa as the original homeland of the Yoruba, the covers of subsequent reprints show a crowned bronze head, thereby also linking Yoruba history with the region of Ife. The history and folklore of the Yoruba people have played a major role in the recent proliferation of popular art and mass-manufactured products relating to the bronze head, and are important sources for understanding the head itself, as well as the reasons why this effigy of the deity Olokun is used in so many different ways.

Mythology and folklore
In Yoruba folklore Ife is regarded as the birthplace of humankind:

> Obatala and Oduduwa were sent by Oludumare to the world, in order to create the land. Together they carried the bag of the world. On their way they rested and they drank some palm wine. Obatala liked the wine so much that he became drunk, and fell asleep. Oduduwa picked up the bag of the world and continued on his own. When he had completed his descent, he found that all was water. He opened his bag, and he found some black earth inside it. He piled a little mound of earth on to water. He took the cock with five toes which Oludumare had given him and placed it on earth. The cock began to scratch and the earth spread far and wide. When Oduduwa had created the earth, the sixteen major *orisha* descended from heaven and they lived with him in Ile-Ife.
> Ulli Beier, *Yoruba Myths*, Cambridge 1980, p. 9

Seven of Oduduwa's sons wore the beaded crown, the central attribute of royalty, but his other children also founded powerful kingdoms in their own right. The mightiest of those kingdoms was Oyo-Yoruba, whose second name was chosen by the Europeans in the nineteenth century to describe all peoples living in the south-west region of what is now Nigeria. Although the people of this region share many cultural traits and a common language, they never united themselves under a single kingdom. Instead, they were originally known by the names of their political communities or their regional dialects and organized into hundreds of minor polities, ranging from villages to city-states to large centralized kingdoms.

The history of Ife

Ife (or Ile-Ife) is one of the Yoruba towns that were the most densely populated pre-colonial urban centres of Nigeria: by 1850 some cities already had as many as 60,000 inhabitants. It is not known exactly when Ife was founded, but the fact that its kinglist includes around forty-five rulers suggests an early date. From archaeological evidence, the town seems to have emerged around the ninth century. We do know that by the fifteenth century Ile-Ife was the capital of a fairly large kingdom. When the Portuguese explorer and slave trader John Affonso d'Aveiro visited Benin City in 1485 he mentioned the existence of a bronze from Ife. His report is usually taken as evidence that the bronze heads existed before the arrival of Europeans on the coast of West Africa.

During the first part of the 1850s the population of Ife was driven out by that of its 'twin town' Modakeke, a settlement created in the nineteenth century for Yoruba people from the territories of Oyo and Ibadan. Ife people were only allowed to return five years later, a situation which led to several resettlements of both towns. King Adelekan, the ruler of Ife in 1896, tried to end the conflict and remove Modakeke residents from Ife for good by handing over three works of art known as the 'Ife marbles' to the then British colonial governor, Gilbert Thomas Carter. According to Samuel Johnson, the king hoped that the gifts would make the governor amenable to enforcing a

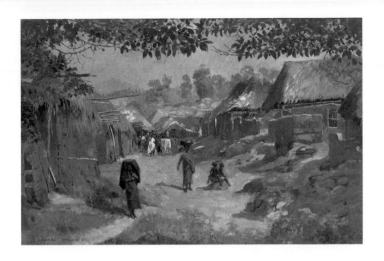

permanent settlement of the conflict in his favour. Historians, and those interested in the oral traditions of Ife, regard the rivalry of Ife and Modakeke and the ensuing turmoil as a reason why knowledge of Ife's history is sparse, and why religious practice was discontinued.

Frank Willett was renowned for his active interest in the ethnographic context of the antiquities found at Ife. Having worked in and on Ife from 1957 until his death in 2007, he agreed that the internal conflicts and population displacements, particularly during the nineteenth century, led to a discontinuity of traditional practices and a loss of understanding of the history and use of objects among Ife inhabitants. Different priests gave varying accounts on separate occasions, a situation with which ethnologists have to cope quite regularly. As Willett notes, this did not happen because people deliberately wished to mislead him, but rather because there was genuine confusion in the tradition.

Sites and objects of remembrance

Like many African regions, Yorubaland – and Ife in particular – is home to various sites that carry historical and mythological significance, at which the ancestors are remembered by objects of memorial. These may be trees, stones, or artefacts such as the granite column of Opa Oranmiyan at Ife, over five metres high and believed to be

29

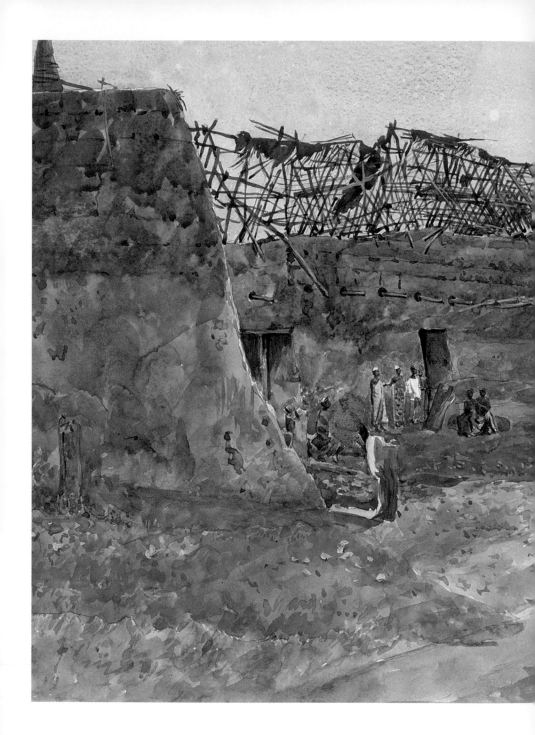

19 Carl Arriens, *Palace of the Oni of Ife*, 1910. Watercolour, 32 x 48 cm. Frobenius Institut, Frankfurt am Main

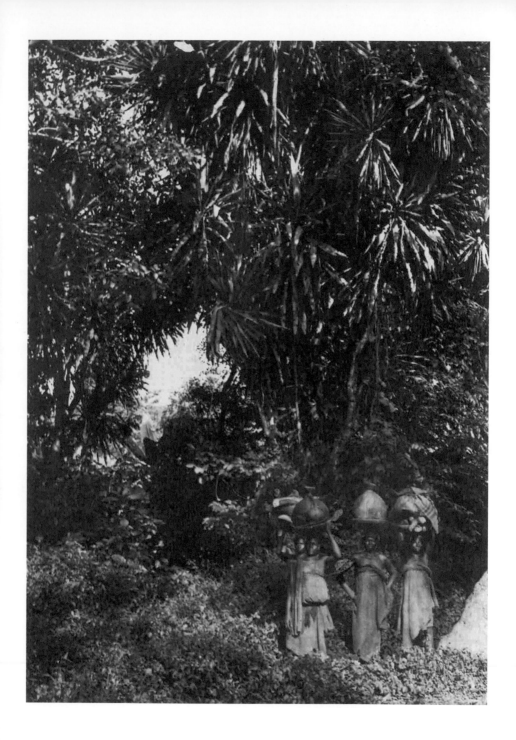

20 *left* The entrance to the Olokun grove in Ife, photographed in 1910.

21 *right* The Olokun grove in Ife, photographed in 2007.

the walking stick of Oranmiyan (Figs 22 and 23). A son of Oduduwa, Oranmiyan is said to be the fourth Oni of Ife, a great warrior and founder of the kingdoms of Oyo and Benin. The meaning of the relief carvings on the column is unclear; the same applies to the iron nails hammered into it.

Other important sites of remembrance are the sacred groves, such as the Olokun grove (Figs 20 and 21), where the first crowned bronze head was found in 1910. Some of them are in the town of Ife itself, in areas where small bushes are left to grow, fenced in by walls and gates. Others can be found within the farmland surrounding the town, where there are surviving patches of forest. These groves are marked by a special type of tree and usually have a small path leading to them. The shrines themselves may be as simple as a domestic pot placed upside down, but on occasion they can be a permanent hut made of mudbrick or temporary shelter constructed for the annual ritual, housing a figure and other ceremonial objects. Most groves are extremely difficult to find, except during festivals. They are allowed to become overgrown when not in use and the antique objects employed during their annual 'resurrection' are kept somewhere else or buried in the earth for the rest of the year. Today, most sites are under the supervision of Nigeria's National Commission for Museums and Monuments. They are fenced and labelled and a gatekeeper is assigned to them. The number

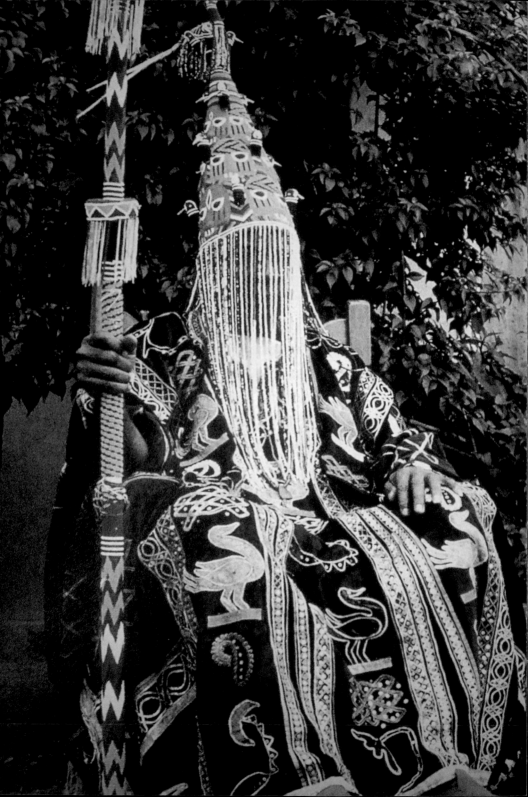

20 *left* The entrance to the Olokun grove in Ife, photographed in 1910.

21 *right* The Olokun grove in Ife, photographed in 2007.

the walking stick of Oranmiyan (Figs 22 and 23). A son of Oduduwa, Oranmiyan is said to be the fourth Oni of Ife, a great warrior and founder of the kingdoms of Oyo and Benin. The meaning of the relief carvings on the column is unclear; the same applies to the iron nails hammered into it.

Other important sites of remembrance are the sacred groves, such as the Olokun grove (Figs 20 and 21), where the first crowned bronze head was found in 1910. Some of them are in the town of Ife itself, in areas where small bushes are left to grow, fenced in by walls and gates. Others can be found within the farmland surrounding the town, where there are surviving patches of forest. These groves are marked by a special type of tree and usually have a small path leading to them. The shrines themselves may be as simple as a domestic pot placed upside down, but on occasion they can be a permanent hut made of mudbrick or temporary shelter constructed for the annual ritual, housing a figure and other ceremonial objects. Most groves are extremely difficult to find, except during festivals. They are allowed to become overgrown when not in use and the antique objects employed during their annual 'resurrection' are kept somewhere else or buried in the earth for the rest of the year. Today, most sites are under the supervision of Nigeria's National Commission for Museums and Monuments. They are fenced and labelled and a gatekeeper is assigned to them. The number

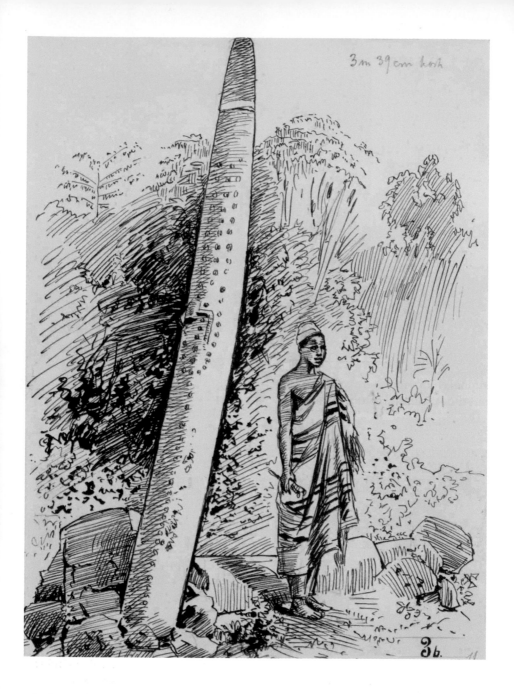

3m 39cm hoch

3b.

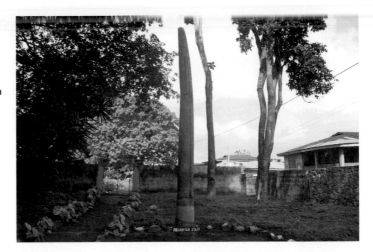

of shrines corresponds to the number of deities worshipped in Ife and is said to vary between 201 and 401, although Kenneth Murray in 1943 was only able to identify 120.

The connection of the crowned bronze heads with Olokun rests mainly on the fact that the first was found in the grove dedicated to that deity. From the conflicting traditional evidence it would seem that Olokun, though generally asexual or ambisexual, was honoured as male in the kingdom of Benin. It is only recently that the figure came increasingly to be regarded as a goddess of wealth in Ife and commonly thought of as the wife of Oduduwa. In the 1930s this view was corroborated by the Oni of Ife, who pointed out that the headdresses applied to crowned bronzes, terracotta heads and figurines were used by female, not male, members of the royal dynasty.

Although the king or Oni has few official governmental functions today, his office, and those of other titleholders, are regarded as essential parts of the traditional institutions of Ife. His duties include presiding over the cycle of festivals commemorating creation and all major events relating to Yoruba and Ife history.

As a sacred king, the Oni embodies in his person the nation, the people, their land and their history. The king as an individual can die, but the institution he represents is seen as undying. This concept of the 'king's two bodies' finds

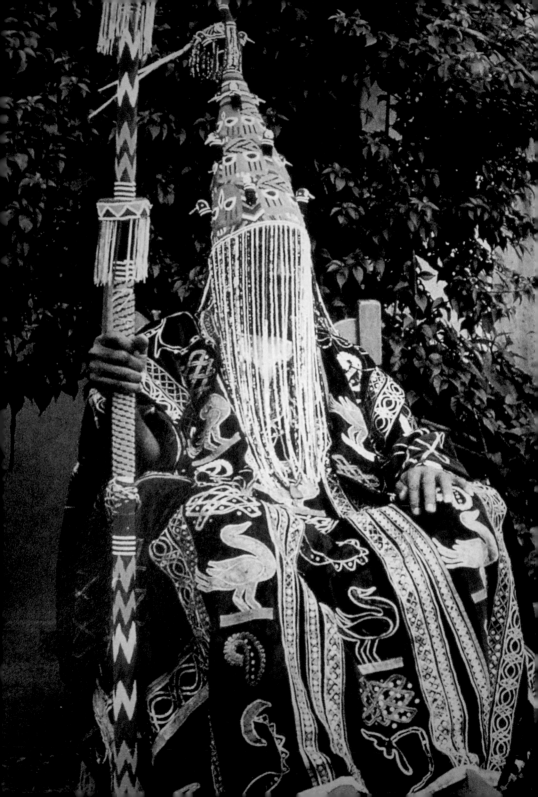

its expression in several objects symbolizing the duration
of the monarchy they stand for. His sacredness is also
expressed by specific behaviour expected of the king, as
well as other people when approaching him. The king
should generally avoid contact with the common world, and
should not do or be seen to do the same things as his
subjects, such as eating or touching the floor. In order not
to be seen by the public, he hardly ever leaves his palace
and, if he is obliged to do so, for instance during certain
festivals, he must dress up in such a way as not to be seen.

The crown worn by Yoruba rulers today fits this purpose
very well. The crown, or *ade*, is a specially designed, beaded
piece of headwear with closely arranged long strings of
beads that cover the face completely (Fig. 24). It conceals
the ruler's identity, while at the same time protecting the
viewer from the power of the king's direct gaze. Other
Yoruba regalia include the royal staff, a decorated white
cow's tail, sandals, embroidered umbrella, gowns and boots.
Although most Yoruba crowns are today decorated with
beads, they vary in colour and design. As the Nigerian
historian Anthony Ijaola Asiwaju demonstrated in 1976, the
popularization of the Yoruba crown in the twentieth century
is closely connected to British colonial politics. Since
Britain's official acceptance of traditional rulers depended
on proof that they had inherited their office or crown, and
only those rulers who could successfully prove this were put
on the official paylist, Yoruba interest in claiming such status
increased, and with it the variations and numbers of crowns.

As in other areas of the world, the royal art of Ife
represents the immense efforts by various members of
society to make visible the difference between the ruler and
the ruled. Rare objects made out of prestigious and
expensive materials are exclusively used to adorn the king,
a materialized social difference underpinned by the specific
shapes and ways in which the objects and costumes are
made. As such the royal objects underscore the political
authority of the ruler. Although we can only guess at what
functions and meanings the British Museum bronze head
held for the people of fifteenth-century Ife, it may well once
have played a central role in such a royal setting.

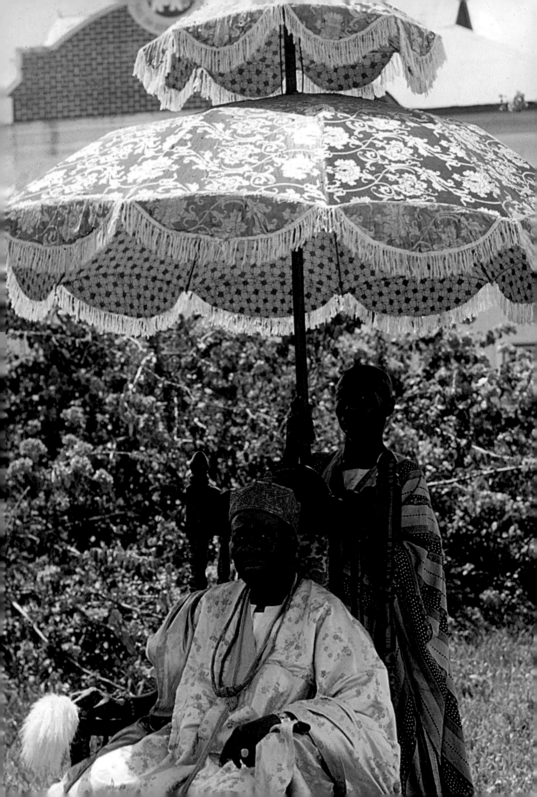

Exhibiting the bronze head from Ife

Exhibiting the bronze head from Ife

25 *left* Kabeyesi Sir
Adesoji Aderemi KBE,
KCMG, Oni of Ife from
1930 to 1980,
photographed in 1959.

26 *overleaf* 'Excavation
of antiquities in Ife',
1910. Plate from Leo
Frobenius, *Und Afrika
sprach*, I, Berlin 1912,
opp. p. 88.

From 1934 many antiquities unearthed at Ife, including
the extraordinary bronze heads found at the Wunmonije
compound, were taken to the Oni's palace for safekeeping.
The photographers Herbert and Eva Meyerowitz visited
the palace in 1938 and took pictures of the collection *in situ*.
Although the artefacts received some public interest in
Europe from articles published with illustrations of the
crowned bronze heads, the outbreak of the Second World War
shifted attention to other, more pressing issues. It was not
until 1948, when Oni Adesoji Aderemi (Fig. 25) lent the Ife
bronzes to the British Museum for display, that they received
wider European attention.

Ife antiquities in Europe before 1948
Very little was known in Europe of the artistic tradition of Ife
before the 1948 display of the bronzes in London, since few
pieces had left Nigeria before then. At the end of the 1940s
the only Ife objects in the British Museum's collections apart
from the bronze head were a terracotta head, terracotta
fragments from a stool group and other sculptures, a quartz
stool and a fragment of a glass-making crucible. The only
piece that had attracted attention was the stool carved
in quartz with a looped handle.

The stool was the first Ife object to come to the British
Museum. It was given by the Oni of Ife to Captain Bower, the
first Resident and Travelling Commissioner for the interior
Yorubaland from 1893 to 1897. Bower passed it on in 1896 to
Sir Gilbert Carter, the British colonial governor of Lagos from
1891 to 1897, together with two similar stools. In 1956 Sir
Gilbert's widow gave one of them, a four-legged stool, to the
National Museum in Lagos. A third object of this kind was
found in 1958 by Kenneth Murray in the stewards' quarters of
a house close to the Government House in Lagos. It resembled
the one at the British Museum, but its handle was broken off.

An incomplete terracotta face must have been brought to
Europe around 1900, since in 1911 a plaster cast of it in the

British Museum formed Charles Hercules Read's principal argument against Leo Frobenius's claim of being more knowledgeable about Ife art than the British Resident at that time. It is not known when the cast was made, and the history of the original – now in the Brooklyn Museum, New York, which acquired it in 1954 from a private collection – is obscure.

Also known in Europe before the important discovery of the bronzes in 1938–9 was a group of objects acquired in Ife by Frobenius in 1910 (Fig. 26). This consisted of the Olokun crowned head, an impressive group of nine terracotta heads, and the other antiquities and 'ethnographic objects' that formed the bulk of his collection. Some of the objects were sold by Frobenius in 1913 to the Museum für Völkerkunde in Berlin, where the terracotta heads and about seventy other pieces remain today. Other objects were passed on to various museums in order to fulfil the contracts Frobenius had finalized before his fourth expedition to Africa, where he bought objects to sell in order to finance his travels. Frobenius published widely on most of his Ife discoveries. His publications, and the plaster copies of the terracotta heads that ended up in African collections throughout the world, may have contributed to the partial fame of those artefacts. The original appearance of the Olokun head is known mainly through photographs taken in 1910 by Frobenius and the colonial resident Charles Partridge (Fig. 27), since what was thought to be the authentic head was found in 1948 to be a modern reproduction.

The story of this 'found and lost' bronze head has been told often and at length, and has played a key role in colonial encounters between the British and the Germans in Nigeria. The main protagonists, Frobenius and Partridge – both in their colonial attitudes very sure of their own connoisseurship of African art and insights into 'how to handle Africans' – seem to have been quite opposite characters. But whereas Partridge was the official representative of the colonial power, Frobenius was an uninvited, if highly experienced, explorer and ethnologist, visiting Ife for just a few weeks and provoking arguments with most of the people he encountered. It is quite possible that he took the head and left behind a replica, as was suggested in negotiations with the Oni at that time. However, it could also be the case, as suggested by Willett, that the

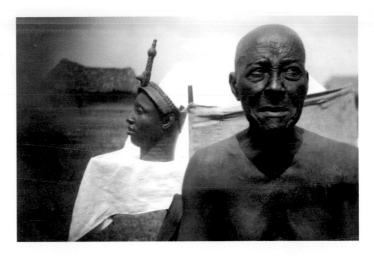

27 Olokun priest with the Olokun crowned head, found in 1910 by Leo Frobenius and now presumed lost.

reproduction was made some time between 1910 and 1934, when it was brought to the palace for safekeeping.

Exhibiting the heads in the British Museum, 1948

In 1946 H.J. Braunholtz, Keeper of the Department of Oriental Antiquities and Ethnography at the British Museum, undertook a trip to West Africa for the Colonial Office in order to assess the region's museum needs. When he was there he visited Ife, where he suggested to the Oni that seventeen bronzes should be sent to England for much needed restoration and possible exhibition at the British Museum. The Oni agreed, and in 1947 the objects – with the exception of the Olokun head and the bronze mask of Obalufon which represented an Ife king – arrived in London. The two objects left behind were subsequently brought over by the Oni himself when he visited England in the summer of 1948. The British Museum returned all the heads to Nigeria in October 1948.

British scholarly and public interest in the bronzes did not cease on their return to their homeland; replicas had been made of all the pieces, which were used in subsequent exhibitions (Fig. 28). In addition, the results of the technical studies made during the few months of their stay in London were published. Aside from the irritating discovery that the Olokun/Frobenius head was a modern

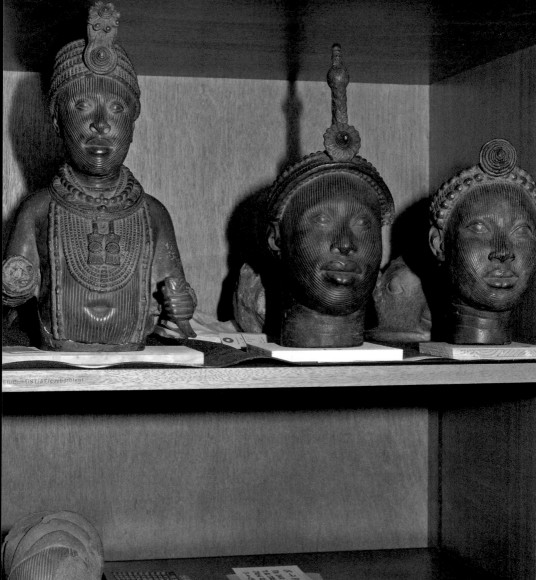
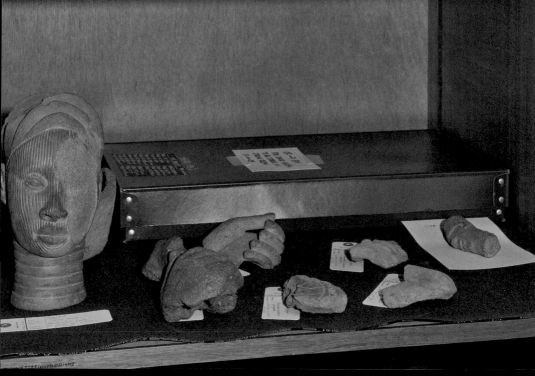

28 *left* Casts made in 1947–8 of some of the Ife bronzes, as they are kept in the storerooms of the British Museum.

29 *overleaf* Bronze heads from Ife on display at the 1948 exhibition *Ancient Bronzes from Ife, Nigeria*, held at the British Museum.

reproduction, other assessments proved the authenticity of the rest of the bronze sculptures from Ife.

Following their examination and restoration, the bronze heads were exhibited at the British Museum in 1948. The presentation was displayed mainly in a single showcase and called 'Ancient Bronzes from Ife, Nigeria' (Fig. 29). The life-size heads were grouped together with the Obalufon mask, whereas the British Museum crowned head and the Olokun head were displayed separately. Two other heads were too badly damaged to be included in the exhibition.

The Festival of Britain, 1951

During the immediate post-war years it was difficult to find adequate space or sufficient financial support to furnish the desolate showrooms. Many museums were still closed, and much of London was in ruins. The British Museum had been hit during the war by several bombs and had been forced to evacuate its collections. It was in this climate that the Festival of Britain, held between May and September 1951, was devised to provide space for a variety of exhibitions and presentations of technical innovation and artistic skill. The Festival was intended to include an international component, so a programme of three exhibitions about the Commonwealth was held at the Imperial Institute. One depicted life in various colonies, while another – organized by the Colonial Office – focused on 'colonial progress'. The third, 'Traditional Art from the Colonies', showed traditional crafts and sculpture with the intention of representing all territories comprising the British colonies, at that time West Africa and the Pacific. More than half the objects came from Nigeria, the most populous of the colonies, and the Ife bronzes and terracottas formed a key part of the exhibition. In addition to the bronzes lent by the Oni of Ife, the two heads that Bascom had taken to America were also shown. Various museums and individual collectors, such as Kenneth Murray and Leon Underwood, also contributed to the presentation.

Like the preceding exhibitions, the opportunity to present such a rich selection of non-European art was generally welcomed. However, the way in which the objects were shown was criticized, along with the decision only to display objects from the colonies. Henry Moore, who was deeply interested in

45

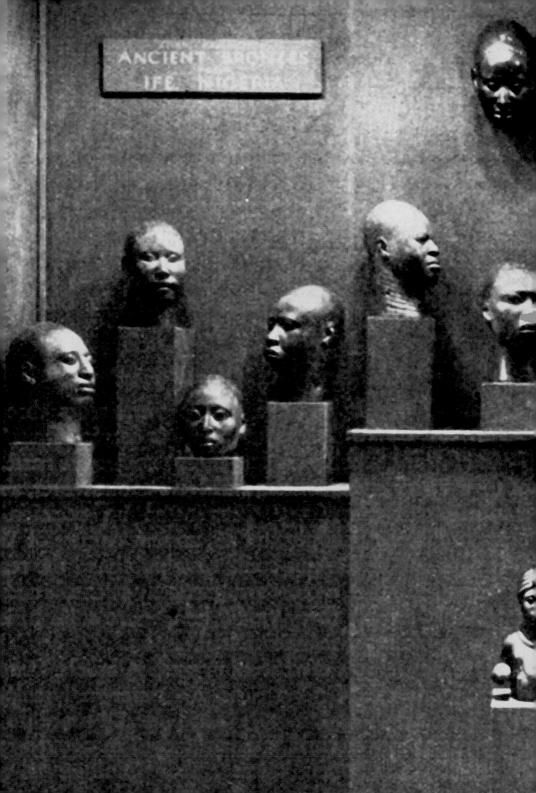

ANCIENT BRONZES
IFE · NIGERIA

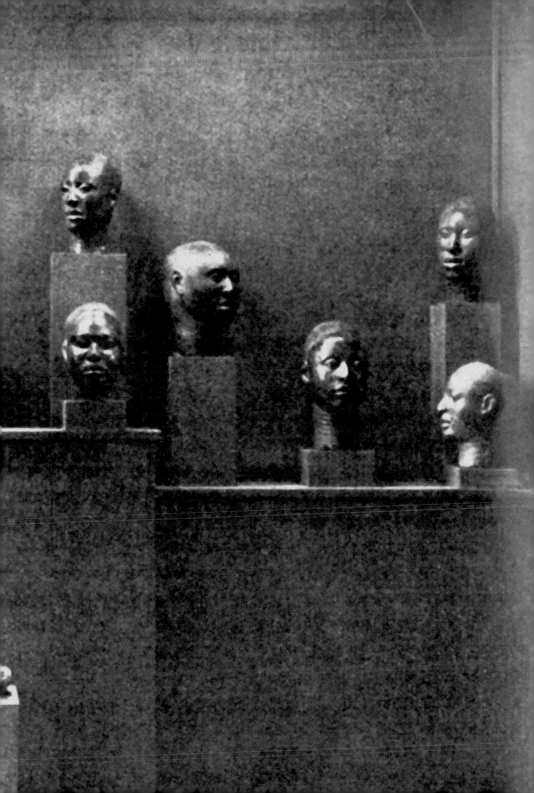

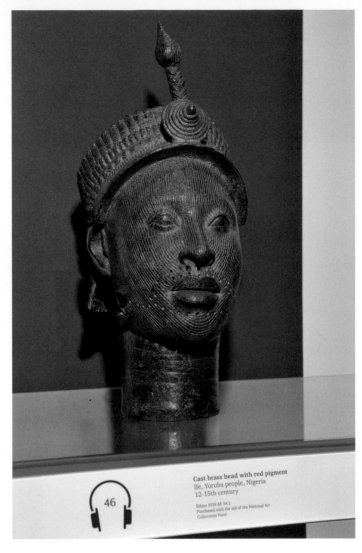

30 The British Museum crowned head as it is currently exhibited there in the Sainsbury African Galleries.

Cast brass head with red pigment
Ife, Yoruba people, Nigeria
12-15th century

Ethno 1939 AF 34.1
Purchased with the aid of the National Art
Collections Fund

46

the sculptures produced by non-European artists, announced in an interview about the exhibition his appreciation of the objects and respect for the nature of the materials. Kenneth Murray, connoisseur of Nigerian art, on the other hand, noted that the display reminded him more of objects in a 'china shop' than of works ranking among man's greater artistic achievements.

Subsequent exhibition of the British Museum crowned head

The extensive group of artworks from Ife did not feature prominently in any of the important exhibitions of Nigerian royal art and bronze work mounted in the following decades. If an exhibition focused on issues of divine kingship, for example, it would concentrate heavily on the British Museum's collection of material from Benin; the crowned bronze head from Ife was presented only alongside casts of other Ife antiquities. If the focus was placed on the treasures of ancient Nigeria – as in one widely discussed exhibition of the 1980s – the key pieces were those housed in Nigerian museums. The British Museum head did not fit into such a concept. Instead the replica of the Frobenius head was illustrated in the introductions to the various catalogues, and the head that had been returned to Ife from America in the 1950s was included in the exhibition. Nigel Barley, curator of the West African section, included the crowned bronze head in the exhibition 'Man and Metal in Ancient Nigeria' at the British Museum in 1991. Together with the head, seventy other pieces from the Museum's collection of ancient Nigerian bronzes were displayed. After that the head was only shown in an exhibition held by the National Art Collections Fund, which had made it possible for the British Museum to acquire the sculpture in the first place.

Aside from its inclusion in temporary exhibitions, the bronze head has a prominent position on permanent display at the British Museum. When the African collections of the Museum returned to the main building in Bloomsbury in 2001, after thirty years at the Museum of Mankind, the crowned head received a new presentation. Displays were mounted in specially built galleries, and spacious showcases were filled with a wide range of impressive objects from all over the African continent. In the gallery where the Benin plaques are mounted and the ivory pectoral mask from the same region is on display, the bronze head from Ife has found a place worthy of its dignified aura from where he – or she – can observe the coming and going of visitors (Fig. 30).

Und Afrika sprach . . .

Wissenschaftlich erweiterte Ausgabe
des Berichts über den Verlauf der dritten Reise-
periode der Deutschen Inner-Afrikanischen
Forschungs-Expedition in den Jahren
1910 bis 1912

Mit Unterstützung des Hamburgischen
Museums für Völkerkunde herausgegeben von

Leo Frobenius

Chef der Deutschen Inner-Afrikanischen Forschungs-Expedition

Erster Band:
Auf den Trümmern des klassischen Atlantis

Zweiter Band:
An der Schwelle des verehrungswürdigen Byzanz

Dritter Band:
Unter den unsträflichen Aethiopen

Vierter Band:
Die ewigen Wege

Chapter 5
The reception of the head by British artists

Considering that the Ife head is today one of the most highly prized objects in the British Museum's African collections, it is surprising that the bronze and related sculptures were basically ignored by British artists in the first half of the twentieth century. One possible explanation for this lack of interest is that, during the first decade of the twentieth century, Western artists had largely turned their attention away from the naturalistic, if idealized, Neo-classical tradition. In doing so they had little or no interest in a style of African art which in their eyes largely resembled the classical European tradition that they wanted to escape. Sculptures and masks from the Fang, Dogon and other ethnic groups were studied by famous painters such as Picasso, Matisse, Derain and Vlaminck who sought inspiration in the archaic and the so-called 'primitive'. These artists were fascinated by the exotic formalism of objects from Africa and Oceania and sought to integrate this new visual language into their own artistic expression. The re-evaluation of African objects from artefacts to works of art that had taken place at the beginning of the twentieth century, mainly in Paris, soon reached other major European cities.

The first exhibition in Britain of the work of the Post-Impressionists was held at the Grafton Galleries in London in 1910. The main artists featured – Cézanne, Gauguin and Van Gogh – provoked a drifting away from the naturalism of Impressionism towards a series of avant-garde movements. Roger Fry (1866–1934), the British art critic who had organized the exhibition, was criticized for his initiative and deemed insane; the artists themselves were no less stigmatized as childish and degenerate. Although the exhibition irritated the London art establishment, the huge impact it had on a new generation of British artists is undeniable.

Henry Moore (1898–1986)

One of the few London-based artists to be inspired by the art of Africa, Oceania, the Pacific and other non-European cultures was the sculptor Henry Moore. Moore lived and worked in London from 1921 onwards, and often visited the British Museum to study sculptures from different periods and cultures. He produced several sketchbooks in which his systematic approach to the study of non-European sculpture becomes obvious, and he was a careful observer of the Museum collections, which were most fascinating in the 1920s and 1930s, as described by the French art critic André Salmon: '. . . many amateurs of negro art, knowing the poverty of the French national collections in this respect, will have taken the trouble to revisit the incomparable collection at the British Museum'. Moore also studied private collections, such as Jacob Epstein's collection of African and Oceanic carvings, as well as the most relevant publications on non-European art, most of which neglected bronze, favouring wood sculptures instead. His main sources were the books of Ernst Fuhrmann, Carl Einstein and Leo Frobenius (Fig. 31): Moore owned a copy of and drew inspiration from Frobenius's 1933 book *Kulturgeschichte Afrikas*. Much like Picasso, who had never visited Africa but who greatly influenced young African artists emerging in the post-colony, Moore's work was not only influenced by African art, but also itself influenced the output of African artists through patrons and teachers such as Frank McEwen in Zimbabwe, or Ulli and Georgina Beier and Susanne Wenger in Nigeria. McEwen, for example, took works by Picasso and Moore to Salisbury (Harare) in travelling exhibitions. Moore's monumental sculptures especially must have provided a model of how stone can be exploited as a sculptural medium.

As a connoisseur and art critic, Moore was invited by William Fagg to participate in the important exhibition 'Traditional Art from the Colonies' during the Festival of Britain in 1951, at which four plaster casts of the bronze heads were exhibited. On that occasion he was asked to answer a number of questions on the nature of tribal art, and his expertise on the criteria defining sculptural quality

The handwritten register book entries read approximately:

AF 31 — 1 — Composite knife, curved iron blade, wooden handle bound with copper. L.18.1"

AF 32 — 1 — Brass bell of European form with flaring mouth. L.6.1"

AF 33 — 1 — Ivory tusk carved all over with xoomorphs with receptacle lidded at wider end. L.27.7"

AF 34 — 1 — Brass head of a man wearing elaborate crested head-dress cast by the cire perdue process in naturalistic style; green patina with bands of red on head dress. L.14.3"

AF 35 — 1 — Wooden figure of kneeling woman supporting a lidded bowl in form of fowl. L.14.5"

AF 36 — 1 — Clay bust male, grey, yellow + red with feathers on head.
— 2 — do. female, grey, yellow, red + blue.

32 The entry for the head in the British Museum's register book from 1939.

was later requested again when Fagg selected objects for his 1970 exhibition at the British Museum, 'The Tribal Image'. Within such a context, it seems a logical consequence that the Henry Moore Foundation, together with the Sainsbury family, became the chief donors for the newly constructed African Gallery at the Museum in 2001.

Jacob Epstein (1880–1934)
Another artist for whom the British Museum and its ethnographic collections were a key source of inspiration was the American-born Jacob Epstein. One of the pioneering figures in the history of British sculpture, his own work was partly overshadowed by the fame of his collection of 'primitive art'. Like Henry Moore in the 1920s, Epstein too had turned away from the classical ideal of beauty. The artists of that time dismissed modelling in favour of direct carving, and wanted to create sculptures based on intense feelings instead of anatomical accuracy. Moore and Epstein, like other artists, were fascinated by the

'magical' and formal qualities of the so-called 'primitive' art, which acted as a stimulus for their own artistic development. Thus it is not surprising that the crowned bronze head and terracotta heads from Ife, famous for their naturalistic style and extraordinary technical craftsmanship, were not widely received by the British art scene at a period when artists wanted to communicate the projected emotional power of tribal art.

Leon Underwood (1890–1975)

One of the few artists to develop a serious interest in West African sculpture in general, and the Ife bronzes in particular, was the British painter and sculptor Leon Underwood. Underwood travelled widely in Iceland, northern Spain, Mexico and West Africa, and worked his experiences into his creations. According to art historians, his work – characterized as a 'pervasive and ideological "Primitivism"' – created expressive forms with allegorical themes. What makes Underwood an important figure for understanding the bronze heads from Ife is his recognition of them as outstanding works of art and their contextualization within the setting of European art history, which he elucidated in several articles, booklets and experiments in casting methods.

Although some of Underwood's statements may sound obscure today, others were important at the time of their publication and are still today. He criticized Western artists for interpreting the art of the past and the art of Africa without considering culturally specific beliefs and for having added their own intellectual variation of its form, divorced from this content. For Underwood, the general adoption of African formalism by the artists of Europe largely amounted to an act of iconoclasm and did not do justice to – and in fact disadvantaged – the art of Africa.

His expertise on West African art expanded during his travels there in 1945, when he gave lectures for the British Council and assembled a large collection of carvings, pottery and textiles. On his return to Britain, he began to involve himself in bronze-casting experiments and wrote on African art, partly in association with the Ethnography

department of the British Museum, especially the curator William Fagg. It was during this collaboration that his suspicion that the Frobenius head was not original, which arose during his visit to Ife, was proven to be correct. This conclusion was based largely on findings published in a joint article with William Fagg in 1949, 'An examination of the so-called Olokun head of Ife, Nigeria', especially the fact that the head was made by sand-casting, a technique not used in ancient Ife.

Chapter 6
The head in contemporary Nigeria

The importance of the crowned bronze head from Ife
is clear from the multiple meanings and significances
it carries in its homeland of Nigeria. Both the object itself
and the many reproductions and images of it function
as a symbol of national and regional identity. The bronze
head – like other icons of African art no longer used in
their original context – is part of a living and continuing
tradition that has survived precisely because it is
constantly changing.

We do not know why the production of bronze objects,
which started around the twelfth century, was
discontinued some time in the fifteenth century.
But we do know that the bronzes and terracotta heads
from ancient Ife are not the only artistic tradition to have
died out, although the objects themselves have survived.
The famous works from Nok, produced in Nigeria
between 500 BC and AD 200, are another example of
a discontinuation of artistic production. The renewal,
evolution and abandonment of types, styles, materials
and functions have long been part of the continual
changing and development of art in Africa.

In the twentieth century, several events had a great
impact on the reinvention of the use of the bronze heads.
First was Nigerian independence, gained in 1960. Since
then the market for reproductions has flourished,
especially among the Yoruba people. The Yoruba are the
dominant ethnic group of the modern-day city of Ife, or
Ile-Ife, which in 2008 comprised approximately 570,000
inhabitants and is located in Osun State in south-west
Nigeria. Their total population is estimated at about 20
million, living mainly in Nigeria but also in the Republic
of Benin and other countries both on the African
continent and abroad. The present-day Yoruba regard
themselves as the cultural heirs of the art of Ife,
considered to be their place of origin. There remains
a wide sense of pride in their historical institutions, and

the Yoruba as a whole still revere Ile-Ife and her artistic accomplishments. This statement, however, must be qualified in several ways. The degree of attachment to this heritage is determined by socio-cultural factors. Westernization and the adoption of Islam and Christianity have lessened the adherence of many to elements of their Yoruba heritage, but Ife's claim for its ancient civilization in comparison to that of other Yoruba communities remains unchanged. While one may have some reservations concerning this claim, Ife is still a vital centre for research into the cultural practices of the Yoruba, since no other city rivals it in terms of both the quantity of its art and the variety of materials used.

Classical Nigerian artworks have been used over the last few decades as vehicles for national ideas and symbols. For example, the 1973 All-Africa Games and the 1977 World Black and African Festival of Arts and Culture (Festac), both held in Lagos, used as their logos the crowned bronze head from Ife and the British Museum's ivory pectoral mask from Benin respectively. This publicity for the Ife head led to a boom in the production of replicas and inspired new renditions of the bronze (Fig. 35). Since we know of three crowned bronze heads that are regarded as originals, the reproductions draw from the iconography of all three, sometimes singly, sometimes in combination.

Political and economic developments since the 1970s have further compounded the trend towards a proliferation of bronze head reproductions, the most important being the Udoji Commission, which greatly affected the consumer behaviour of the Nigerian population. The Udoji Public Service Review Commission was initiated by the then Head of State General Yakubu Gowon in 1973 to examine the wage structure of the civil service. As a consequence of its findings, the commission issued a decree stipulating an across-the-board wage increase, in some cases even doubling salaries. With this rise in income, nearly everything became a commodity, and money was spent in abundance. This heralded not only an increased demand for Western goods, but also a Nigerian market for pieces previously created mainly for the airport and tourist trades. Various art objects

were now reproduced in all sorts of sizes and materials, and used in the developing interior design market.

Although reproductions of the Ife antiquities – made for decorative purposes and to be given as gifts – are often crude and carelessly made and cannot be compared to the outstanding craftsmanship of the ancient bronzes, they nevertheless contribute enormously to the popularization of the Ife corpus. In Nigerian homes and hotels, Ori Olokun is used to decorate a wide range of objects, and replica sculptures in various materials abound. It has also come to grace the entrances of several major landmarks; at the Airport Hotel in Lagos, for example, it is featured everywhere and was even chosen as the name of the hotel's bar, the 'Olokun Bar' (Figs 33 and 34).

Similarly widespread is the use of Ori Olokun in corporate logos and branding. As the goddess of wealth, Ori Olokun is considered a particularly appropriate figure for business enterprises and educational institutions,

33 The sign of the Airport Hotel, Lagos, includes a stylized representation of the Ori Olokun head; photographed in 2007.

34 The Olokun Bar
at the Airport Hotel,
Lagos; photographed
in 2007.

as well as television channels. One of the biggest investment groups in Nigeria, the Odu'a Investment Company Ltd, uses the head as its logo, and many educational institutions have adopted Ife heads as central emblems of their logos, notably the Obafemi Awolowo University at Ile-Ife, one of the foremost universities in Yorubaland, founded in 1962. With a strong emphasis on cultural studies and identity, it is no surprise that Ori Olokun features prominently on the university seal. The head also features on the official logos of the national television channels at Ibadan and Ile-Ife.

Such use of the bronze head is not a recent phenomenon, nor is it restricted to Nigeria alone. The bronze head, together with a panel from a Yoruba door, appeared on a 5,000-franc banknote issued by the Central Bank of West African States. Nigeria has never been part of the monetary zone this currency was made for, nor had it ever used that type of paper currency. The art historian Susan Vogel suggested in 1994 that one reason these artworks were depicted on the banknote was that they are among the oldest and most elaborate ever known from the region, and have become universal symbols of African heritage.

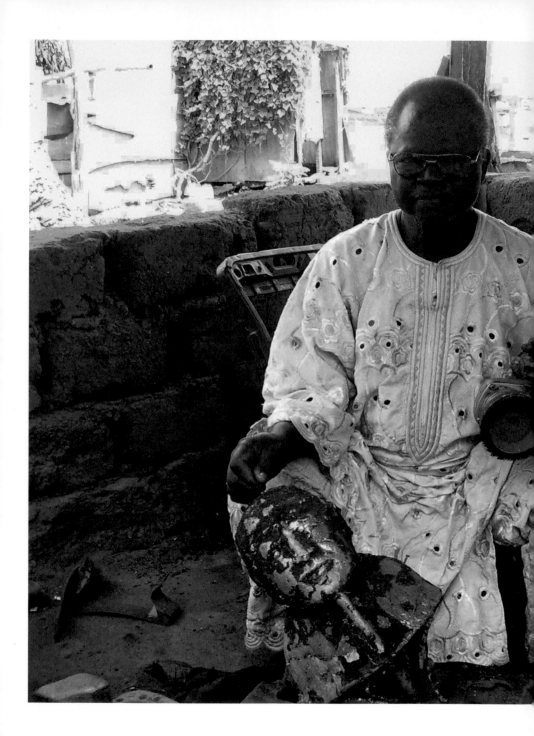

In the 1960s and 1970s the crowned bronze head became – and remains – a symbol of both African and Yoruba identity. During the Nigerian Civil War (Biafra War), which ran from 1967 to 1970, Nigerian museums were instructed to rewrite all their labels in order to omit completely any reference to the ethnic provenance of works, including those from Ife. Only the names of individual villages were given, and the museums were asked to present in their displays art from every region. Exhibition policy has since changed, and the crowned bronze heads housed in the National Museum at Ife are now generally presented as the first window into Yoruba art and culture. Together with the famous Ife terracotta sculptures, made in a similarly naturalistic style, replicas of the heads are today displayed in a number of Nigerian national museums, notably those of Enugu, Ibadan, Ife, Jos, Kaduna and Lagos.

Further Reading

Anthony Ijaola Asiwaju, 'Political motivation and oral historical tradition in Africa: the case of Yoruba crowns, 1900–1960', *Africa* 46/2 (1976), pp. 63–77

William R. Bascom, *The Yoruba of Southwestern Nigeria*, New York 1969

Ulli Beier, *Yoruba Myths*, Cambridge 1980

Suzanne Preston Blier, *Royal Arts of Africa. The Majesty of Form*, London 1998

William B. Fagg and Frank Willett, 'Ancient Ife, an ethnographical summary', *Odu* 8 (1962), pp. 21–35

Leo Frobenius, *Und Afrika sprach*, 3 vols, Berlin 1912–13

Sidney Kasfir (ed.), *Contemporary African Art*, London and New York 1999

John Mack (ed.), *Africa. Arts and cultures*, London 2005

John Pemberton III and Afolayan S. Funso, *Yoruba Sacred Kingship: "A Power like that of the Gods"*, Washington DC 1996

William Rubin (ed.), *"Primitivism" in 20th-Century Art: Affinity of the Tribal and the Modern*, 2 vols, 5th edn, New York 1994

Leon Underwood, *Bronzes of West Africa*, London 1949

Susan Vogel (ed.), *Africa Explores: Twentieth Century African Art*, New York 2004

Frank Willett, *The Art of Ife* (CD-Rom), The University of Glasgow, 2004

This book deals with what social anthropologists term 'the social life of objects'. For further reading on this subject, see Igor Kopytoff, 'The cultural biography of things: commoditization as process', in Arjun Appadurai (ed.), *The Social Life of Things: Commodities in Cultural Perspective*, Cambridge 1986, pp. 64–91

Image Credits

Every effort has been made to trace the copyright holders of the images reproduced in this book. All British Museum photographs are © The Trustees of the British Museum.

1 Photo: British Museum; AOA Af1939,34.1. Given by the National Art Collections Fund
2 Photo: British Museum
3 *Illustrated London News*, 8 April 1939, p. 594.
4 © National Commission for Museums and Monuments, Nigeria (79.R.11)
5 Reproduced by permission of the University of Illinois Urbana-Champaign and the Chicago Field Museum.
6 *Illustrated London News*, 8 April 1939, p. 592.
7 © National Commission for Museums and Monuments, Nigeria (30/53, 30/76, 30/77, 30/88, 30/89)
8 Photo: British Museum
9 Photo: British Museum
10 Photo: British Museum
11 © National Commission for Museums and Monuments, Nigeria
12 © Frobenius-Institut, Frankfurt am Main
13 © National Commission for Museums and Monuments, Nigeria (57.1.1)
14 © National Commission for Museums and Monuments, Nigeria (79.R.7)
15 Photo: British Museum
16 Photo: British Museum
17 © Frobenius-Institut, Frankfurt am Main (fotoarchive 4-8554)
18 © Frobenius-Institut, Frankfurt am Main (EBA-B 00417)
19 © Frobenius-Institut, Frankfurt am Main (EBA-B 00421)
20 © Frobenius-Institut, Frankfurt am Main (fotoarchive 4-5014)
21 Photo: © National Commission for Museums and Monuments, Nigeria
22 © Frobenius-Institut, Frankfurt am Main (PBA-B 00076.b)
23 Photo: © National Commission for Museums and Monuments, Nigeria
24 Photo: Jack Pemberton
25 Eliot Elisofon Photographic Archives, National Museum of African Art, Smithsonian Institution, Washington DC (EEPA EECL 2111)
26 © Frobenius-Institut, Frankfurt am Main
27 Partridge Archive, British Museum; AOA Af,A167.37
28 Photo: British Museum
29 Photo: Archives of the Department of Africa, Oceania and the Americas, British Museum
30 Photo: British Museum
31 © Frobenius-Institut, Frankfurt am Main
32 Photo: British Museum
33 © Editha Platte
34 © Editha Platte
35 Photo: © National Commission for Museums and Monuments, Nigeria